T0166169

The Mosaics of Delos

Anne-Marie GUIMIER-SORBETS

ÉCOLE FRANÇAISE D'ATHÈNES

ΓΑΛΛΙΚΗ ΣΧΟΛΗ ΑΘΗΝΩΝ

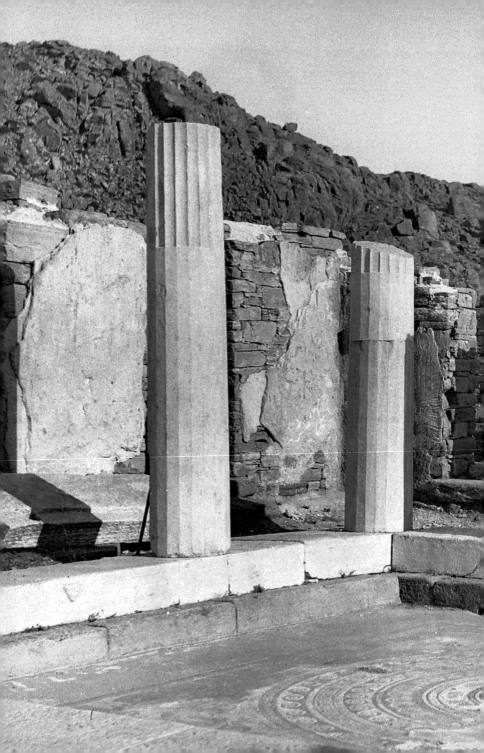

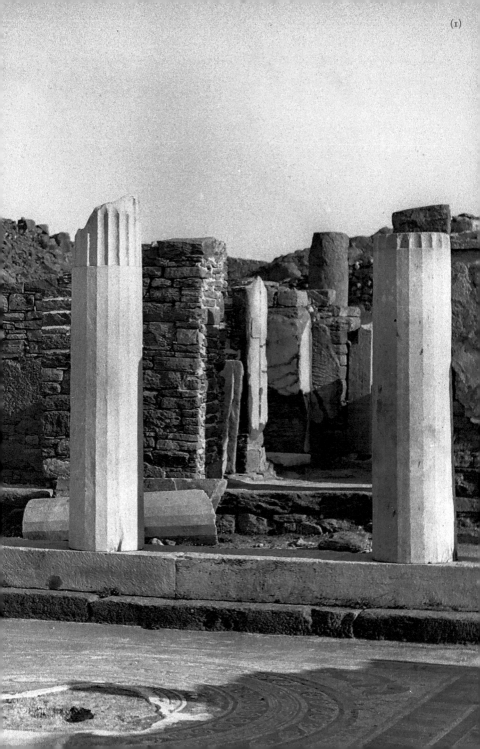

In memory of Philippe Bruneau

Author's Note

This little book with its many colour illustrations has been written to set out the gist of our knowledge about the mosaics of Delos for a broad audience. In an endeavour to present the mosaics in their architectural setting, cross-references are made to the *Guide de Délos* (*GD*) and also to the *Atlas de Délos* recently edited by Jean-Charles Moretti and that can be found on the Internet (see 'Further Reading' at the back of the book). The locations of buildings where mosaics featured in this book have been found are shown on **map 1** of the cover flaps and identified by their *GD* number circled in red. For further information, readers are of course referred to the corpus of mosaics by P. Bruneau: their numbers are given in square brackets.

Chronology

314–167: Delos was an independent city state, the seat of an international sanctuary of Apollo and a regional port of commerce.

172–168: Third Macedonian War: Rome victorious against Perseus, King of Macedonia.

167: The Roman Senate handed Delos over to Athens, which drove the Delians from the island and established a cleruchy.

130–68: Production of the vast majority of the Delian mosaics.

88–84: First Mithridatic War between Rome and Mithridates VI, King of Pontus.

88: Mithridates VI plundered Delos and massacred its inhabitants.

75–63: Third Mithridatic War between Rome and Mithridates VI, King of Pontus.

69: Athenodoros, a pirate in the pay of Mithridates, ransacked Delos. The Roman legate Caius Triarius had a rampart built.

67: Pompey's war against the pirates.

Introduction

When, from the seventeenth century onwards, antique mosaics were discovered in ancient excavations in Italy they were more often than not cut out and removed from the buildings where they were found. Collectors prized their figured panels (see box 1) as remains of antique painting, or they decorated the floors of their newly built palaces with them. In either case, only the part that was removed was conserved, while what remained in place was doomed to destruction sooner or later. Large collections of mosaics were compiled in the great museums of the western capitals and at Carthage and Antioch up until the first half of the twentieth century. By contrast, the pavements of Delos, unearthed at the time of the first excavations in the late nineteenth century, were left in place (1), with only fragments from the upper storeys of houses being deposited with the museum. Thereafter a few very rare panels in danger on the site were removed and presented to the museum, but they did not leave the island, unlike a number of sculptures, for example, now housed in the National Archaeological Museum of Athens. The mosaics of Delos are all preserved on the island and, in the great majority of cases, in their original location, maintained in an exceptional setting since the entire island is a protected archaeological site. This first distinguishing feature of the Delos mosaics – that is not without its urgent problems of conservation – means they can be studied within their proper architectural setting. Their second distinguishing feature is that they are many in number and almost all of them are contemporaneous having been produced over a comparatively short span of time between 130 and 68 BC. They therefore form a unique group both for the study of mosaics and, in conjunction with the paintings and stuccos of the same buildings, for the study of architectural decoration of Hellenistic times.

The significance of the mosaics did not escape the earliest excavators on Delos. As long ago as 1908 Marcel Bulard gave over volume XIV of the prestigious *Monuments Piot* review to the paintings and mosaics of Delos. In 1922–1924, in instalment VIII of the *Exploration archéologique de Délos* (*EAD*), Joseph

Chamonard studied the different types of floors of the Theatre Quarter. In 1972 Philippe Bruneau in instalment XXIX of the *EAD* compiled a corpus of all of the island's mosaics, as had been begun to be done for the major sites in different countries, in line with the recommendations of the *Association internationale pour l'étude de la mosaïque antique* (AIEMA) from the time of its founding by Henri Stern in 1963. P. Bruneau worked through the field notebooks of his predecessors, classified the museum fragments and set about describing the mosaics in a systematic manner, using an unequivocal descriptive terminology developed with René Ginouvès. This painstaking method of study, to which we are all indebted, enabled him to write the fundamental book that is the reference work to this day.

The amazement felt every time one disembarks on Delos is prompted first by the grandiose setting of the ruins of the sanctuary, the port quarter, and the tiers of houses climbing the slopes of Mount Kynthos, the hill that overlooks the island. The amazement continues when entering the Theatre Quarter by the narrow winding streets that afford views of the wealthy houses lining them. Of the walls preserved to heights of several metres, one notices the stacked gneiss slabs that make them up, now that the plasterwork that served as their inside and outside facings has disappeared. From the streets, almost indiscreet glimpses through house hallways reveal the remains of coloured wall decorations and the mosaics that covered the floors of the courtyards, peristyles*, and the rooms leading off from them, as in the House of Dionysos (120) or the House of the Trident. Further on, tattered patches of mosaic cover the collapsed cisterns.

Nowadays the mosaics with their characteristic decor are part of the Delian landscape that one comes upon while walking around the site (2) or in the museum, where the more fragile panels are exhibited. On the ground floor or upper storeys, they formed part of the architectural decoration of buildings, like the paintings and stucco work that enlivened the inside walls in conjunction with the domestic sculptures, the lighting arrangements, the furniture and textiles that have now disappeared.

The excavations carried out over about a third of the surface area of the island since 1873 by the French School at Athens in collaboration with the Greek Archaeological Service (Ephorate of the Cyclades) have led to a hundred or so houses being unearthed. Some 350 pavements or fragments have emerged from the ruins, with about 160 of them bearing decoration of varying degrees of complexity.

Although primarily part of the domestic space, mosaics also decorated sanctuaries like that of the Syrian gods (98) on the terrace of Kynthos and public or private buildings like the Agora of the Italians (52) or the Clubhouse of the Poseidoniasts of Berytos (57). Overall, these mosaics were produced over a comparatively short span of time; they form the largest known group for the Hellenistic epoch and so take on particular significance in the history of antique decoration.

(2)

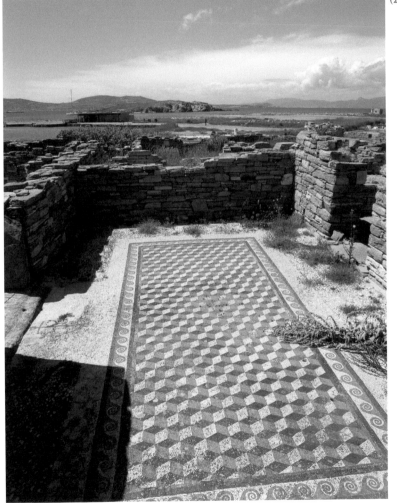

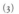

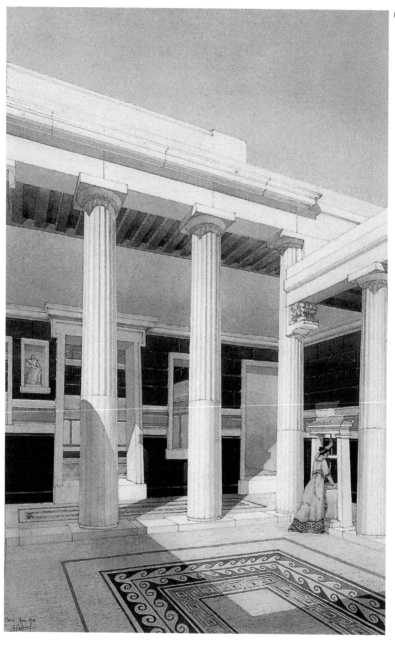

(3)

The Mosaics of Delos

Mosaics in the home

HOUSE OF THE TRIDENT

Upon entering the House of the Trident ⑪⑧ from Theatre Street, the long hallway leads to the courtyard with its Rhodian peristyle*, standing higher on the side facing the entrance and giving onto the *œcus maior** (3). This wealthy abode with a floor area of some 370 m², not counting the upper storeys, had no fewer than six mosaic pavements on the ground floor: above the cistern, the floor of the courtyard serving as the *impluvium** for rain water is covered by a mosaic formed by two symmetrical lines of waves (see box 2) and a meander of swastikas and squares in perspective (2), a motif of refined polychromy and design [229] (4). The floors of the peristyle walkways were also covered with white mosaics, punctuated by carpets (1) of simple and elegant decoration: a single row of waves and a red stripe mark the entrance to the *œcus maior*, whereas a dolphin twisting around an anchor signals the main entrance to the house, and a ribboned trident marks the side entrance [228] (see 53 and 54). On the floor of the *œcus maior* a rectangular mosaic carpet stands out framing a central panel – doubtless figured – that was removed back in Antiquity [236]. The space left between the walls and the decorated part of the pavement was used for setting out the dining couches. On the floor of the *œcus minor* a black-figure panathenaic amphora*, a palm frond with a strip of ribbon, and a wreath can be made out, all prizes awarded to the winners of panathenaic contests [234] (5). This carpet is edged with a meander of 2D swastikas and squares. In the small corner room opening onto the two reception halls, the mosaic carpet, bounded by a black frame-band (1) bears a decoration of waves with a composition of cubes in perspective (2) [235]: this *trompe l'œil* composition of three-coloured lozenges, laid out so that the variously lit faces of adjacent cubes appear, is one of the illusionistic motifs the Greeks were fond of. They enjoyed the paradox of walking on a smooth floor with motifs that looked to have depth; the same was true of the meander with swastikas and squares in perspective of the courtyard

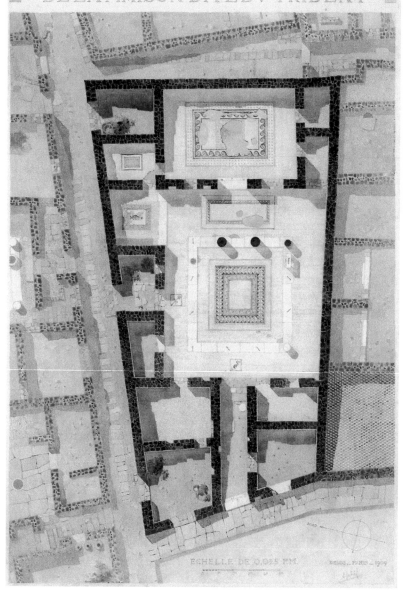

PLAN·DE·L'ETAT·ACTVEL
DE·LA·MAISON·DITE·DV·TRIDENT

(4)

ECHELLE DE 0.025 PM

pavement. In addition to these ground floor pavements were those of the upper storeys, a single fragment of which, composed in *opus signinum* (1) with a meander, was found during excavation in the early twentieth century. The House of the Trident is the Delian dwelling with the highest proportion of mosaic flooring.

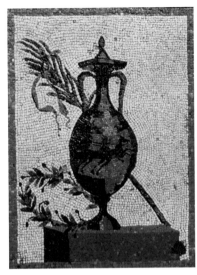

HOUSE OF THE MASKS

South of the theatre, the House of the Masks 112 occupies a large part of a huge insula (housing block) bordered by a colonnaded street; its floor area is about 690 m² (**map 2**). The hallway leads to a Rhodian peristyle, with the raised side giving onto the particularly luxurious *œcus maior*. The courtyard impluvium is covered with a mosaic of marble chips. In four of the rooms that lead off from the courtyard, the mosaics of varied composition display figured decoration.

The first room to the right of the entrance has a rectangular doormat mosaic (1) adorned by a polychromed rosette (2) on a dark ground inhabited by birds pecking at berries; the rosette is carried by long green sepals laid out along the diagonals of the doormat mosaic [214]. In the main carpet (1) bordered by waves, three figured panels with dark grounds stand out against the white ground on which can be seen a scatter of branches and ivy and laurel wreaths identical to those worn by banqueting guests or awarded to winners of contests (6). On the nearly square (1.08 x 1.06 m) central panel, in a very fine *opus vermiculatum* (1), Dionysus, richly clad in oriental style, sits 'side-saddle' on a leopard (7). The god, crowned with ivy, brandishes the thyrsus* and the *tympanon**, his favourite musical instrument. He is wearing long, finely folded and overlapping clothes of bright contrasting colours. He is thus depicted on his triumphal return from the Orient, where his divine nature was recognized. The leopard, a wild animal tamed by the god, joins in his triumph with its ivy collar tied by a strip of crimson ribbon. On the two diamond-shaped side panels in *opus tessellatum*,

(6)

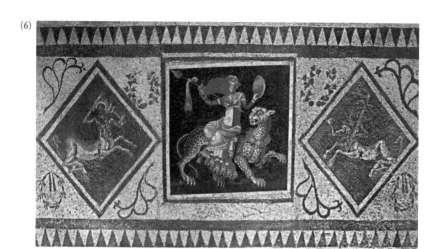

(7)

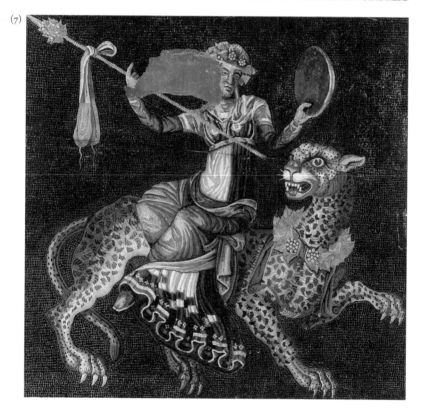

(8)

centaurs gallop symmetrically to take part in the banquet in honour of the god: one carries a gilded krater*, the other a torch. These are no longer wild hybrid beings, forest hunters, but followers of Dionysus who has civilized them and taught them to drink watered-down wine at banquets. It can be seen that, symmetrically, the centaurs' hind legs slightly overlap the mosaic frames (Is this because of the difficulty placing these figures in the narrow diamond-shaped panels or rather an attempt to create an effect of movement?): the centaurs seem in this ways to be springing up to meet the god.

The floor of the very large *œcus maior* (9.30 x 7.20 m) is mostly covered by a composition of *trompe-l'œil* cubes in red, black, and white [215]. On each side, an extension on a light ground bears a sprig of ivy whose leaves and fruit (corymbs*) are recognizable, with theatre masks hanging from them. Rendered in colour by a fine *tessellatum*, these ten masks, facing the centre of the room, bear the distinguishing features of characters of the New Comedy (8).

The adjoining room is smaller and meant for fewer guests, but it is just as carefully decorated [216]; the single carpet is surrounded by waves running in alternate directions with birds in the corners and a slender garland of laurel and ivy with corymbs at the ends of the two strands running in opposing directions (9). In the centre, a scene of music and dancing stands out against a dark ground: the musician, sitting naked on a boulder, facing forward with his head turned to show his left profile, is playing the *aulos*; his companion, who is bald, wreathed, and bearded (Silenus*?), is dancing on tiptoe, his left arm stretched forward and his right arm bent, hand on hip, his head is turned and looking at the floor, in a highly expressive way of rendering the dancer's movement. He is wearing a short tunic and a cloak rolled around his hips.

Opposite the room with the Dionysus, a fourth *œcus* opens onto the west walkway of the peristyle [217]. From the threshold, the guests were escorted by two dolphins symmetrically facing the centre of the room. The large carpet with its many borders comprises, on a white ground, two rosettes on black

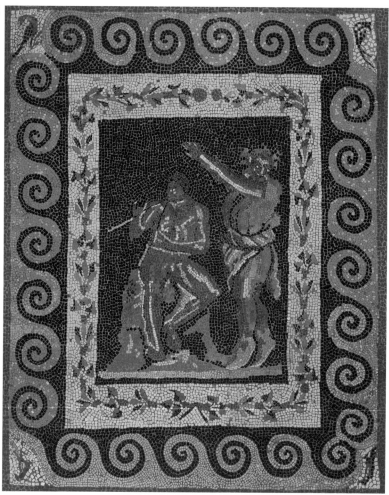

(9)

grounds inhabited by birds perched on twigs. Between the two panels, in the centre of the pavement, a panathenaic amphora with a palm frond and a small bird pecking at berries have been added.

The iconography of all these pavements relates to Dionysus, and we shall come back to this theme. Fragments of a dark blue recipient have been used in place of tesserae (1) both in the dancer's tunic and in the rosette of the pavement with the Dionysus, as well as in a fragment of a mosaic from an upper storey. Moreover,

The Mosaics of Delos

small birds are to be seen on three of these pavements, as well as the change in direction of the border decorations. This set of distinguishing features together with the irregular tesserae and the rendering of the plant ornamentation all show that the mosaics of the house were made by one and the same workshop, although it cannot readily be recognized in the island's other pavements.

HOUSE OF THE DOLPHINS

The third house whose pavements we describe is the House of the Dolphins (111), close to the House of the Masks. This luxurious abode, with its ground floor area of about 450 m², is located on the corner of a block of houses. In the main entrance, fronted by a portico and visible from the doorway, the floor of its large entrance hall is made of white *opus tessellatum*, with a double black frame and a Tanit sign in the centre, pointing to the outside [209] (10). This emblem, which was well known in Carthage and specific to the divinity of the Phoenicians, protected the house against the evil eye and kept out the bad influences of ill-intentioned visitors.

One of the island's finest pavements covered the floor of the impluvium, in the peristyle courtyard [210] (see 1). The square carpet stands out against a white

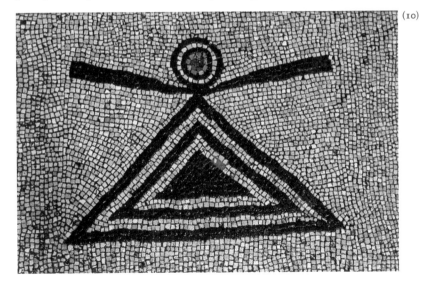

(10)

Mosaics in the home

jointing band (1) and has a crenellation border (2), a motif originally used for textiles, and done here in red and black, with palmettes in the corners (11). Within the square, a large circular panel is composed of a very wide border of sixteen concentric bands most with decoration: there is a chequerboard of red and black tesserae, two lines of waves laid out symmetrically on either side of a meander with swastikas and squares in perspective, a two-stranded guilloche (2), and a bead and reel* pattern; to these geometrical motifs of architectural origin, treated here illusionistically with bright polychrome, two strips are added featuring some remarkable decoration: a garland the stems of which are held by a textile binding, and waves with alternating heads of lion-griffins and eagle-griffins. This motif in *opus vermiculatum* is known only on two other pavements in large reception rooms of the second century BC on Samos and Rhodes (with lion-griffins only). Above the garland binding, that is preserved in part, one can read the remains of the mosaicist's signature, [Askle]piades of Arados (see 30 and 36). The central panel is badly damaged, but one can still recognize, on a dark ground, a rich rosette, with flowerlets at the ends of spiral tendrils and a butterfly. The four spandrels feature outstanding figured motifs made of polychrome *opus vermiculatum*. They are pairs of dolphins that are hitched together and harnessed like horses: each biga* is mounted by a small figure; these tiny winged jockeys – Erotes – are dressed in short tunics of different colours, as for races in the hippodrome. Each tiny auriga* carries the attributes of a god: the thyrsus of Dionysus, the caduceus of Hermes, the trident of Poseidon (see 14) and, poorly conserved, the club of Herakles. In this extraordinary seafaring race, it is the biga of Dionysus that is the winner, as shown by the wreath in the beak of the dolphin whose auriga wields the god's thyrsus (12). This pavement, which is unique in its composition and iconography, – and whose quality is confirmed by it being signed – was damaged by fire. Fragments found in the excavation attest to the presence of other mosaics in the upper storey rooms. However, it should be observed that, unlike the House of the Trident and the House of the Masks, no mosaic has been found of the floor of the *œcus maior*, which very probably had a wooden floor that has since disappeared. The same observation was made for the ceremonial rooms of other wealthy abodes on Delos like the House of Dionysos, the House of the Herm or the House of the Comedians (59B).

(11)

Mosaics in the home

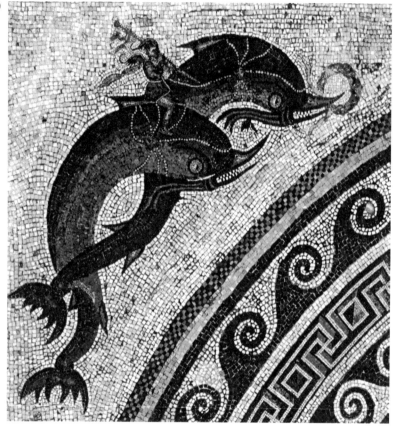

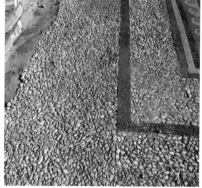

Flooring and mosaic techniques

As in Greek houses as a whole, the floor of many ground-floor rooms was simply rammed earth. In dwelling houses, slab flooring was uncommon and seldom made of marble, but of gneiss flagstones and terracotta, especially in the work rooms, bathrooms, and the courtyard *impluvium*.

On Delos, mosaic-covered floors were widely used. The technique was appreciated because its result was practical (a floor that was waterproof and easy to clean) and neat, or even decorative. Mosaic work is the fitting together and setting in mortar of small tiles of the same or contrasting colours, prepared before being laid from various shapes that are independent of the design. Various materials were used: a good many Delian mosaics are made of chips of marble or pounded potsherds (box 1). These materials came from broken amphorae or chips from marble blocks used for sculpture or building work. Laid on edge on a stabilized floor, these fragments were either entirely covered over by the lime mortar in which they were set (mortar floor) or left apparent on the surface and then finely abraded (chip mosaic). Depending on whether it was made up mostly of lime or of crushed terracotta, the mortar could be some shade of white or pink. These chip mosaics, whether monochrome white or pink-tinted, or two-coloured when the white marble flakes stood out against the pink-tinted grouting, were used for whole rooms (whitish mortar) or to cover cisterns and seal the floors of courtyards and terraces (pink-coloured hydraulic mortar, made into a better water sealant by its high concentration of crushed terracotta). This technique, which could be easily applied and used waste materials, was also used for the outer parts of mosaics in large reception rooms (13).

On those pavements that are not monochrome, one or more **carpets** can be recognized, which are generally rectangular, standing out from the **jointing bands**; these carpets, **main carpet** and **threshold carpet** (or **doormat**), are often edged by one or more bands; we speak of **frame-band** when the black outer band is separate from the rest of the border. These carpets can contain one or more **panels**, which are themselves bordered.

Pebble mosaics are rare on Delos and belong to ancient buildings, as in the rest of Greece. Most decorated mosaics are in *opus tessellatum*, made of small cubes of stones, **tesserae**, with sides measuring a little under a centimetre. To produce very fine designs, mosaicists used tiny components (with sides measuring 1 or 2 millimetres), whose shape could be adapted to the design: *opus vermiculatum* (14). These techniques are attested in Alexandria as from the late fourth century BC (*opus tessellatum*) and circa 200 BC (*opus vermiculatum*) and they spread throughout the Mediterranean basin. In Hellenistic times, the finest parts of mosaics were often made in workshops, on a mortar support, before being set in place in the pavement: these are *emblemata* (singular: *emblema*).

A few floors of *opus signinum*, a mortar floor made up of terracotta powder and chips (pounded fragments of amphora bodies and handles, known as **potsherd**), decorated with tesserae arranged in scattered chequer crosses or diamond gridlines (15); this technique is known from the late fourth and early third centuries BC in Tunisia and then in other regions, especially Sicily; while generally associated with the western Mediterranean it is also found in the eastern part.

(1) *Pavement techniques and composition*

(15)

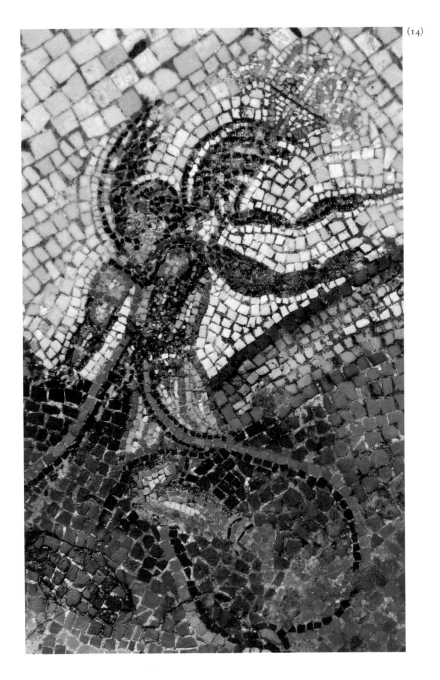

Flooring and mosaic techniques

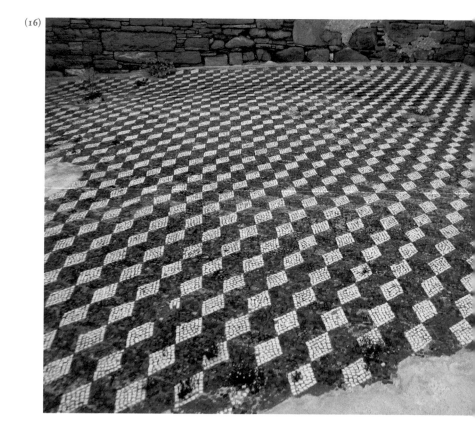

Mosaic designs

The design of a mosaic floor is seldom uniform from wall to wall. And yet this is the case in house IIB, next to the House of the Trident where a room with 6 m long sides is covered entirely by a composition of cubes [242] (16) or in three rooms of house B west of the Clubhouse of the Poseidoniasts (**maps 1–2**) where the floors are covered by chequerboards of black-and-white tesserae [44–46] (17). More often than not, mosaics, composed using several techniques, have a mostly white surface, divided up by concentric stripes of contrasting colours, which themselves may be monochrome or have different types of design, serving as a frame for a central panel with a vegetal or figured design or alternatively a monochrome white centre too (18). In reception rooms, the spaces for banqueting couches along the walls are left blank: in a few houses only (House of the Herm (89), House of the Insula of the Jewels (59A), House of the Comedians (59B)), the area for couches is raised as was the case in earlier banqueting halls. Leaving the entire floor area of the reception room on the same level meant the rooms could be put to more varied use once the banqueting couches and trappings had been stored away in the adjoining rooms.

Almost all of the 160 decorated mosaics or groups of fragments have a geometric design; in about a quarter of these, it is combined with a figured design, of varying size, and a score or so of pavements have a vegetal design.

GEOMETRIC DESIGNS

Geometric designs are therefore the commonest, arranged in bands or larger areas. They may be reversible, two-coloured, like the wave, turret, or sawtooth (crowstepped or not, box 2) designs that were originally textile patterns; the

**Cubes
in perspective (3D)**

Crowstep

Rosette

Leaf pattern

Guilloche

**Meander with swastikas
and squares in perspective**

Diamond tips

Waves

Two-stranded guilloche

Crenellations

(2) *Mosaic motifs*

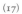

Mosaic designs

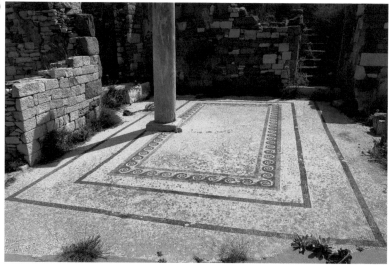

regular spiralled waves come in single or double rows arranged symmetrically. Through their polychromy, other motifs give a *trompe-l'œil* impression of depth. The meanders with swastikas and squares, dentils*, eggs and darts*, imbricated leaves (2), and guilloche (2) all belong to the architectural design repertory: they can be found sculpted, as stucco work, or painted and in mosaic work. Stucco craftsmen and painters imitated the work of sculptors, each with the characteristics of their own technique, and mosaicists in turn imitated painters, playing on colour for illusionistic effects: the parts of the design with their ever lighter colours seem to jump out from the black or dark ground. For the cubes and diamond tips (2), it is the arrangement of simple figures (lozenges, right-angled isosceles triangles) of 2D colours that suggests the volume of cubes (see 16) or of small juxtaposed pyramids [333]. These two motifs are also rendered in *opus sectile*, a highly refined floor covering technique no example of which has been conserved on Delos.

The execution of these geometric patterns, that must have been produced "by the mile" on pavements, did, however, require both precision and suitable materials, especially for the swastika and square meanders in perspective : this refined motif, the 'amazing feat of skill' of mosaicists of the Hellenistic period, involved the use of several colours of tesserae, each in light and dark hues, and signalled the quality of the workshop (19). The mosaicist workshops that operated on Delos

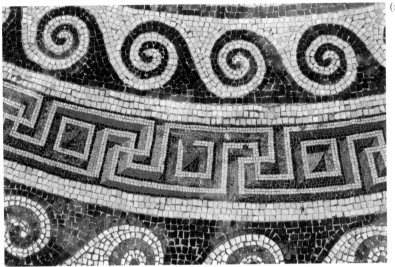

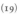

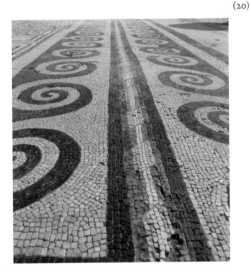

displayed great mastery of the techniques and of the various combinations of motifs. We have just seen, on the pavement of the House of the Dolphins, the polychrome perspectival meander is set between 2D black and white waves. On the mosaic of the *œcus maior* of the Fourni House ⑫⁴, a rich composition of meanders with swastikas and squares in perspective is bounded on its outside by two symmetrical rows of black and white waves on either side of a *trompe l'œil* torus* formed from adjacent red and yellow parallelograms: the grading of their hues peaking with a light central stripe provides a striking volume effect [325] (20); in this way the mosaicist has played with the contrast between two-coloured flat motifs and polychrome motifs with *trompe-l'œil* depth.

VEGETAL DESIGNS

Vegetal motifs are scarcer than geometric ones. Rosettes, centred compositions formed by petals with more or less wavy outlines, sepals, and/or tendrils bearing leaves and flowers, are rendered illusionistically on a black ground. In the reception rooms, they may be at the centre of the main carpet [261] or duplicated [217], or then again placed on the threshold carpet as in the House of the Masks [214]. In the centre of the courtyard, in the House of the Lake (64) [93] or the House of the Dolphins [210], the rainwater of the *impluvium* covered them from time to time. They could also decorate the upper storeys of houses, as in the House of the Tritons [79] (see 44) or the House of the Lake: this elegant floral composition is made up of two overlapping rosettes, each formed from a corolla of sepals and four petals whose variously shaded bands of colour suggest the curved profile [95] (21).

The garlands, made up of vegetal stems held by ribbons, bear fruit that emphasizes the variety of vegetal species (ivy, laurel, olive tree, pear tree,

(21)

The Mosaics of Delos

pine, etc.). There are few foliated scrolls in the Delian mosaics. Theatrical masks and sacrificial bulls' heads may be associated with the scrolls and garlands [68] (22 and 23). In the House of the Masks, the branches depicted on the floor [214] like the vegetal scrolls bearing masks [215] lastingly replicate vegetal features used in banquets and in tribute to the gods to be honoured in the home or at the theatre as in the sanctuaries.

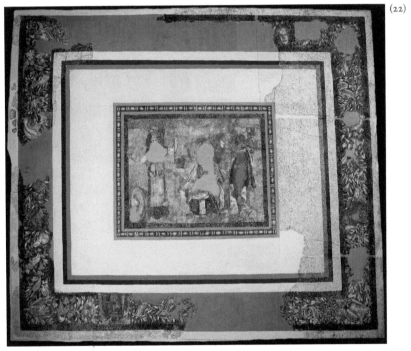

(22)

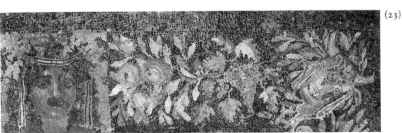

(23)

FIGURED DESIGNS

The figured repertory may display varying degrees of complexity: small creatures populate the vegetal designs (birds, butterflies) underscoring their realism, dolphins swim about and wrap themselves around anchors on the thresholds of some reception rooms [261] (24); at the Fourni House, one panel portrays three fish of different species [328]. These designs have a part in the taste for animals attested to in Hellenistic times, especially among the mosaicists of Alexandria. A panel depicting doves (wood pigeons) on a gilded bronze bowl [168] (25) is one of the earliest copies of an original made at Pergamon by the mosaicist Sosos in the first half of the second century BC according to the testimony of Pliny the Elder (*Natural History*, XXXVI, 184). Still lifes illustrate the prizes of winners at the games, as in the House of the Trident [234] (see 5), the House of the Masks [217], the Fourni House [325], or in the Agora of the Italians [25] (see 37). But genuine pictures with one or more figures are also to be found.

Most of the iconography of the Delian mosaics can be associated with Dionysus, the god of wine, plant growth, the wild world that he civilizes, and also the god of the theatre and the home, who presides over banquets. He is portrayed in triumph in his eastern garb, sitting on a leopard, as in the House of the Masks [214] (see 7). In the courtyard of the House of Dionysos, visible from the entrance and facing the *œcus maior*, lay the most refined panel now exhibited in the Delos Museum [293] (26). The large panel (1.64 x 1.32 m) on a black ground, whose very fine *opus vermiculatum* is damaged in parts, depicts the same scene: Dionysus, his hair down to his shoulders, wreathed with ivy and richly clad in oriental style, is riding a tiger and brandishing his thyrsus. The god, in his prime, is winged, which is rare in Greek iconography and marks both his power and his divine nature, first recognized in the East (27). The tiger, with one paw raised, turns his head back towards the god whom he acknowledges as his master (see the cover illustration); associated with his triumph, it wears a grape-laden vine stem collar; as it runs along the floor covered with wild plants, it overturns a precious wine-filled kantharos* made of gilded metal (28). On a fragment from the upper storey of a house in the Inopos Quarter ⑨⑤ [169], the leopard whose forelegs can be seen together with a garland of ivy leaves and corymbs was undoubtedly that of Dionysus (29).

(24)

(25)

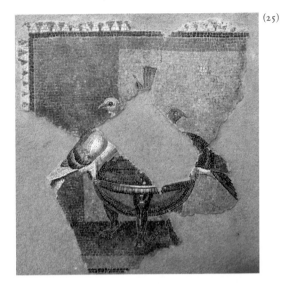

(26)

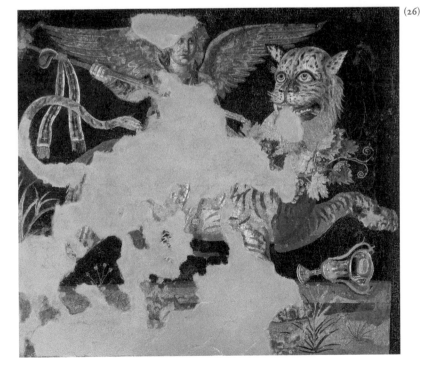

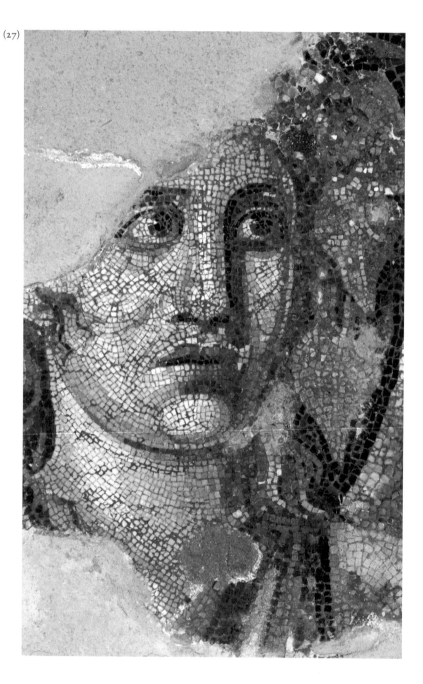

Tribute may be rendered to Dionysus less directly as in the depiction of the race of the dolphin teams, as seen, or by the row of waves with lion-griffin and eagle-griffin heads on the same pavement [210]: griffins are another type of – mythical – wild animal tamed by Dionysus (30). The theatre influenced the Hellenistic repertory and evocation of it is associated with the god who presided over performances and contests in the theatre. Hanging in the vegetal scrolls or in the garlands, or featured on a small panel [347], the masks have a part in the same tribute.

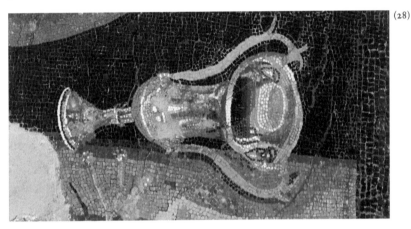

(28)

For patrons and educated guests, it was easy to recognize the god's 'presence' in the scenes where he did not feature in person. They were familiar with the episode in which Lycurgus, King of Thrace, pursuing Dionysus, sought to set upon Ambrosia, one of the god's followers, when the god dived into the sea to escape the king's wrath. On an upper storey panel [69] from the Insula of the Jewels, as on other pavements throughout Antiquity, the king, in a rage, raised his double-headed axe with both hands to strike the floored nymph. Trying to protect herself with her right arm, she struck the ground with her left hand and the god transformed her into a vine whose shoots were to stifle Lycurgus (31). In Hellenistic times, there was no need to write the names of the characters whom everyone recognized, 'seeing' in it the divine intervention that enabled the nymph to win out over the barbarian king and punish him.

In House IVB, only a small part of a panel from an upper floor is conserved [279] (32), but the scene has been restored by comparison with contemporaneous

(29)

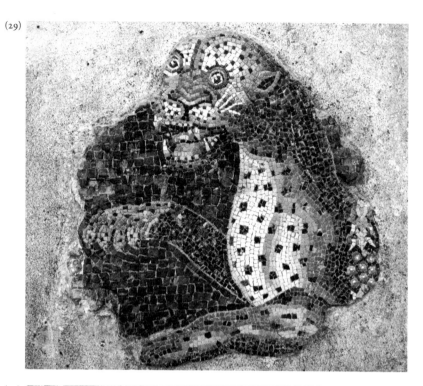

(30)

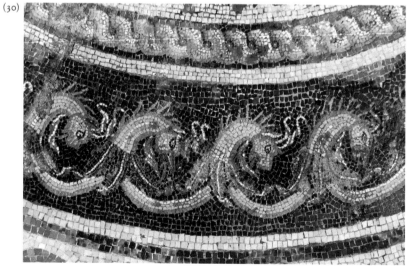

The Mosaics of Delos

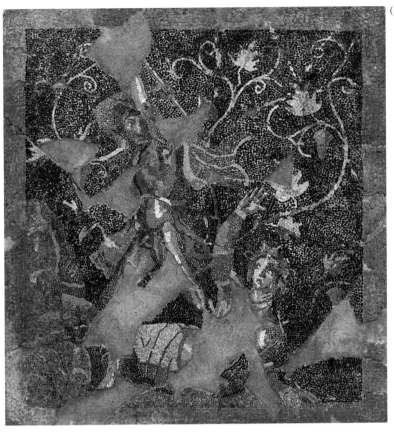

panels found in Italy: two Erotes have managed to tie up a large lion and are playing with it, dangling a cloth before its eyes (33). These playful youngsters are part of the thiasus* of Dionysus, which gives them the power to tame wild beasts just as he could. Without any direct connection with the sons of Aphrodite other than in their physical appearance, the iconography of these amusing and well-meaning figures developed in Alexandria and in the whole of the Graeco-Roman world. These *putti* are to be found in several Delian houses, in mosaics and in paintings in the House of the Dolphins where they get up to various activities. There are many of them in the decoration of Pompeiian houses.

It is probably with the world of the theatre that we should connect a somewhat enigmatic scene with three figures, depicted on a very large panel of the House

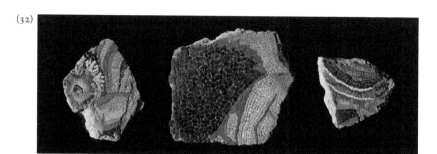

of the Insula of the Jewels [68] (see 22). Surrounded by a rich garland carrying ten masks and bulls' heads at the corners, the panel has a complex polychrome ground against which there stands out in the centre a woman draped in robes,

sitting face on and with a long branch (34). On her right side, helmeted Athena is standing facing forward, holding some sort of plant in her right hand; she is holding her spear in her left hand and her shield is standing at the edge of the scene. On the right, the god Hermes can be recognized from his caduceus, his petasos* on his back, and his winged sandals; naked under his chlamys* which hangs to cover the front and back of his torso, standing side on, he is addressing the central figure. Above the seated woman, one can make out the pink-coloured beam of a loom with a ball of wool of a more prominent hue. Above Hermes, in the top right corner of the scene, a column bears a tripod on its cap, as can be seen on the sculpted metopes* of the frieze of the theatre of Delos. This scene depicts the episode from the Odyssey (X, 203–427), in which Odysseus' companions have been turned into animals by the sorceress Circe by a stroke of her long wand, after having been forced to drink a magic potion. Odysseus set out to fetch them and, on the way, he met Hermes whom the goddess Athena had tasked with giving him a plant (the *moly*) to protect him from Circe's evil spells. Odysseus is not portrayed in the panel but we can see Athena handing over the moly, Hermes her messenger, and Circe sitting

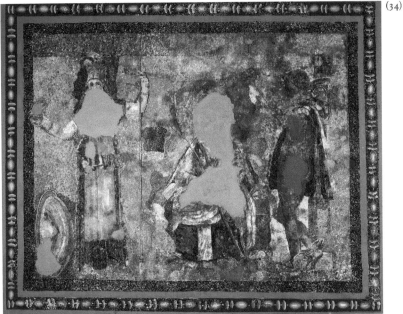

(34)

with her wand, at her loom. The iconographic scheme was a familiar one; an Etruscan mirror housed at the Fitzwilliam Museum in Cambridge relates to the same episode: in a similar composition, Circe is in the centre, sitting at her loom, flanked by Odysseus and Elpenor, one of his companions, both in the same posture as Hermes. On the Delian pavement, the polychrome ground of the scene is somewhat blurred, at least in its present state of conservation,

(35)

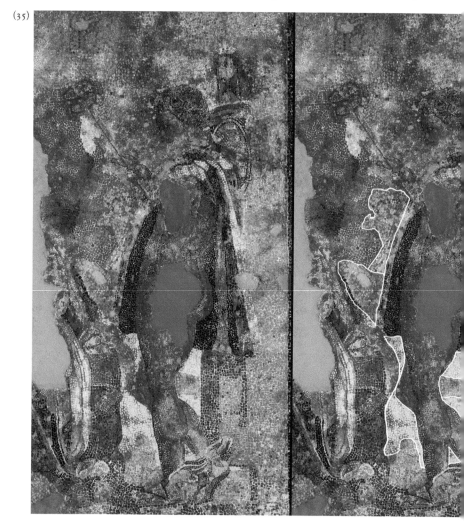

with no further traces of the paintwork that must have highlighted the scene to bring out certain parts of it. It was probably a rocky landscape, as can be seen in several paintings from Rome or the region of Vesuvius of the same period or shortly afterwards, the original type for which came from Alexandria. In the background, behind Hermes, one can make out the walls of a small building, with a door on the less well lit side. Between the god and the sorceress, still in the background, one can see the heads in profile of two creatures, snouts or muzzles to the sky: as in other depictions of the same episode, these were probably companions imprisoned by Circe, whom Odysseus is going to rescue. They are turned back into men through the intervention of the hero with the help of Athena and Hermes (35).

This huge panel (1.83 x 1.37 m) – the largest figured composition on the island – made of fine *vermiculatum* must have transposed a nowadays unknown painting. Surrounded by its marble frame and then a magnificent garland with bulls' heads and masks of the New Comedy, the pavement must have greatly impressed the homeowner's guests. They without a doubt identified the episode from the Odyssey, probably also the play by Aeschylus, only the title of which – *Circe* – has come down to us, or the comedy that two authors of the fourth century BC derived from the episode; but could they all have recognized the scene, or was it the subject of 'learned' conversations during the *symposion**? The guests must have identified with Odysseus, the cunning hero protected by Athena, making them feel valued. Among other meanings, the scene might also suggest the dangers of drink, when taken heedlessly: the choice of subject matter in antique banqueting room mosaics often served the purpose of teaching some lesson. Remember that the panel of Lycurgus and Ambrosia came from the upper storey of the same Insula of the Jewels (see 31): the two scenes share the same objective of paying tribute to Dionysus through mythological episodes one must know how to 'decode'.

INSCRIPTIONS

Few Delian mosaics bear inscriptions: we know of two mosaicist signatures [195, 210] (36) and five pavement dedications: two belong to the Agora of the Italians [16, 25] (37), four to sanctuaries [190, 194, 195, 204], and one to a building near the hippodrome [102]. Lastly, two upper storey mosaic fragments bear isolated letters [42, 349].

(36)

(37)

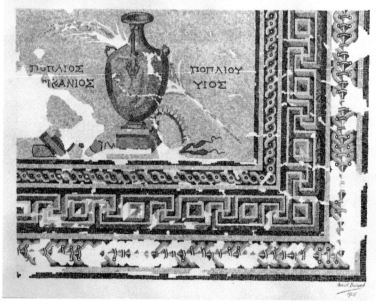

How did mosaicists on Delos work?

TECHNIQUES AND MATERIALS

Whatever the covering technique, making a floor that is to last demands that it rest on a solid subfloor; this is why, on the ground floor, it was necessary to stabilize it by overlaying layers with varying compositions of mortar, earth, and increasingly fine stone fragments. Only pavements more directly overlying the bedrock could escape this constraint. The ground surface obtained in this way then had to be flattened by using stone rollers, several of which have been found in the island's houses for maintaining beaten earth floors. Then a fine-grained mortar screed was poured over the flattened surface and work could then begin on the mosaic proper. First the main lines had to be laid out, the outline of the carpet, in a regular shape unlike the outline of the room, then the edges of the border and any panels and/or threshold carpets. These guide lines were set out using twine sometimes coated with pigments which, once fastened at the ends, pinched, raised and released, imprinted lines on the mortar surface. It was common practice to set lead strips in the still wet mortar along the outlines of the main parts of the pavement: about 2 cm high and standing a few millimetres proud of the surface, they served as guides for laying tesserae in the final layer of fine mortar (setting bed) that was poured as work progressed, to fix the tesserae or chips that had been cut out and sorted by colour beforehand.

Other often thinner lead strips were used in creating the design. It is certain that the patterns of the scenes and the figured motifs were drawn onto the surface of the mortar before the tesserae were laid out. Were these preparatory drawings simply cut into the mortar or were they partially coloured? To date none have been identified beneath the figured scenes of the Delian mosaics,

but their presence is highly likely. Unlike the use observed in pebble mosaics, strips of lead were little used in the figured design in *opus tessellatum*: however, their presence can be observed in the outlines of the palm frond and the wreath in the panel depicting prizes in the Agora of the Italians [25] and in the dolphins with and without anchors [217, 228, 261]. Likewise, these strips are seldom used in the vegetal designs, which were executed in a similar way to the figured designs; however, they are found along the spiralling petal outlines in the two rosettes of the amphora pavement of the House of the Masks [217].

By contrast, lead strips were widely used to draw the components of geometric designs. They hug the spirals of the waves (38), a motif that looks straightforward but that is complex to produce with the rule, set square, and compass that were the craftsman's standard tools, because the regular trace of the spirals had to be followed; it was no accident, then, that 'templates' were found in two of the quarters of Delos, lead cut-outs on which one had just to follow the outline using a hard tip to draw a whorl of the motif in the mortar before it set (39). Each template, of different gauge, corresponded to a given band width and a single wave, so one just had to repeat the operation to reproduce the feature along the full length of the band to be covered; the template could be flipped over to change the direction of the motif, which the mosaicists made no bones about doing, as in the House of the Masks [214, 215, 216]. Along with other clues, the presence of these templates in the houses shows that work was in progress there at the time they were destroyed. These lead strips were also used to draw the outlines of cubes in perspective, bead and reel patterns, imbricated leaves, guilloche, etc. They are found almost everywhere in the linear or areal

(38)

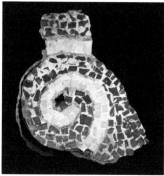

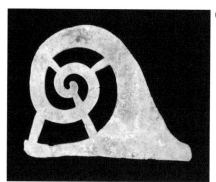

(39)

compositions of meanders with swastikas and squares in perspective, for which it has been possible to show that from a fine grid marked out on the surface of the mortar they drew all the straight and oblique outlines required to produce the motif: once laid out, these strips delimited the spaces to be filled with the setting bed mixture before arranging the coloured tesserae for each of the segments. Only the meander with swastikas and squares in perspective of the dolphin pavement [210] was made without lead strips, but it is a circular composition (see 19); the mosaicists only used them here to delimit the bands placed outside the panel. The perfect rendering of these motifs in difficult conditions is further evidence of the craftsmanship involved in making this exceptional pavement.

MOSAIC COLOURS

The Delian pavements are made up of at least two colours rendered by tesserae of black and white stone; where they have three colours, the presence of red tesserae of terracotta is observed. However, whether for copying the great paintings – one of the major arts of the time –, making depictions more realistic, or enhancing geometric designs, the mosaicists broadened this range in the most luxurious pavements. The external polychromy of Greek monuments had been observed and reproduced ever since the eighteenth century, while it has been recognized more recently for sculpture. Pliny the Elder (*Natural History*, XXXV, 50) tells us that renowned painters limited themselves first to four colours (black, white, red, and yellow); they subsequently adopted more numerous and more dazzling colours, by the fourth century BC at the latest. In the early mosaics, made of pebbles, a rather dull material that was rounded and so did not fit together closely, artificial materials were introduced, lead strips to mark fine lines in imitation of the graphic arts and, exceptionally at Pella, faience beads in the fresh green leaves of Dionysus' wreath. Then, to imitate and vie with painting, its polychromes and its illusionistic style composed of finely graded nuances, the mosaic artists cut the tiles – the tesserae – so they would fit more closely together and adopted new artificial materials to supplement the range of colours of natural stone.

In this way, they used tesserae of glass for bright red, bright yellow, dark blue, bright blue, dark green, and violet, and thin tesserae of faience for light blue, light green, and certain greys. They also brightened up the colours of

stone tesserae with a layer of paint, as was done at the same period on certain architectural elements or on statues. Moreover, to reduce the discontinuity inherent in mosaic work, they coloured the grout in the same shade as the surrounding tesserae, either by adding pigments directly to the mortar mix or by painting over the whole of the area to be coloured. On some upper storey fragments housed in the reserves of Delos Museum, this added paintwork remains in plain sight, as in those of the Fourni House (40); but in most instances the paintwork has faded, or even faded away. Similar deterioration is found for the glass and porcelain tesserae as these materials are less stable than stone. Accordingly, the colour of some glass tesserae has changed or the tesserae are no longer in place because the fixing mortar barely penetrated the glass. Lastly, the surface glazing of faience has often disappeared with its colour leaving just the yellowish paste, as can be seen for example on Ambrosia's blue garment (41). It is not easy, then, to form an idea of the extent of the chromatic palette used and of how brightly coloured the pavements were. Examination of artificial materials – glass and faience – for which the processes and different stages of deterioration are known according to their composition has enabled a start to be made on this research, supplementing the old water colours made shortly after the pavements were unearthed. In this way, for the garland with masks of the mosaic of the Insula of the Jewels [68], we have essentially set about examining the materials (42); we have done likewise for the panel with the Dionysus of the House of the Masks [214], with the help of an old water colour (43). Infrared (VIL) photography has made it possible to identify traces of paintwork made from Egyptian blue, a synthetic pigment known as far back as the third millennium in Egypt and the East and widely used by painters in the Graeco-Roman world. It is easy to detect its presence on the bird perched on the rosette of the House of the Tritons [79]: whereas the surface of the faience tesserae has been worn away, their blue colouring can be restored from that of the joints coloured with Egyptian blue pigments, as confirmed by infrared photography (44). A few traces of this paint are preserved on the panel of the Dionysus of the house of the same name [293]; although now hard to see with the unaided eye, it is apparent in the watercolours by Albert Gabriel and Marcel Bulard, and it is confirmed by infrared photography.

This non-invasive method of photographic examination can be used to differentiate between cases where Egyptian blue paint was applied to tesserae

The Mosaics of Delos

(40)

(41)

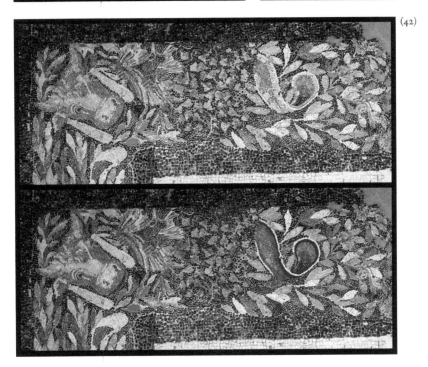

(42)

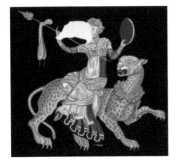

(43)

How did mosaicists on Delos work?

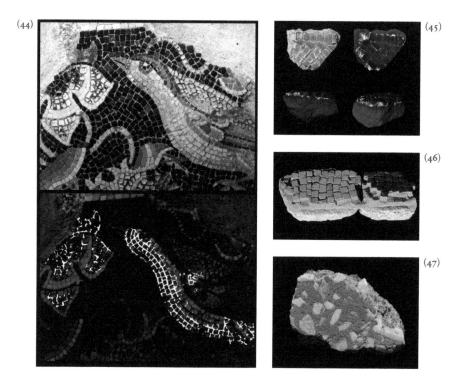

already set in place and cases where the ground pigment was mixed with the mortar of the setting bed (45). By adding pigments to the setting bed it was possible both to force the colour up in the joints and enhance the preparatory scheme by indicating where the colours were to go.

The mortar for pavements could be coloured red by adding potsherd powder (making it more impermeable) or red ochre pigments to intensify the colour. Accordingly there were intensely pink-hued or red mortar floors, or *tessellatum* in which the elements were set in a bright pink setting bed, as in the House of the Tritons [78] (46). Very commonly, once the stones were abraded, the marble chip floors were given a surface coating of red mortar (47). The floors of Delian houses were even more colourful than they are when seen today [72] (48).

But where did the materials needed for making tesserae or the tiny components of *opus vermiculatum* come from? Far and away most of the stones used in the pavements came from the Cyclades, a volcanic region rich in minerals of various kinds and colours. Where did the mosaicists source their supplies of

artificial materials? The island did not have any workshops for making the raw material (primary workshop), but secondary workshops where the glass was processed to make tableware and jewels are attested there and they could have supplied mosaicists with strands or ingots of coloured glass for cutting tesserae. It seems that in Hellenistic times, faience was made in Egypt only, from where the mosaicists would have had brought the small plaques from which they cut the tesserae. This trade in faience items is widely attested, especially on Delos; bringing in plaques should not therefore have been a problem, nor would the procurement of natural pigments (ochre, green earth, orpiment*) or synthetic pigments (Egyptian blue) widely used by painters.

WHERE DID THE MOSAICISTS WORK?

In contrast to the expression 'potters' workshop' used for permanent premises, a 'mosaicists' workshop' refers to a team of itinerant workers since most of their work was done *in situ*, inside the buildings to be decorated. Because of the number of mosaics made on Delos in the course of two generations or so, it is a sure thing that several workshops were active there at once, which did not

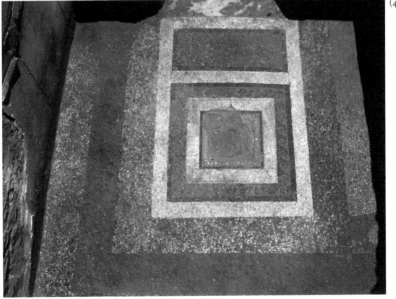

(48)

How did mosaicists on Delos work?

preclude patrons from calling on the services of craftsmen from other lands, whether settled on this island or just passing through. The names of only two mosaicists are known there, one being Asklepiades of Arados, from the Syrian-Phoenician coast [210] (see 36).

The mosaicists worked on the surface to be covered, which were floors only at this time, and their work advanced bit by bit, since the setting bed had to be poured as they progressed to avoid it setting too soon. In some monochrome zones, the straight boundaries of the series of stages of laying the mosaic can still be seen (see 13). From the very beginning of the second century BC, in Alexandria, mosaicists made the finest panels not directly in the pavement but on a table in a place reserved for the purpose: on a thick plaque of mortar, under good lighting, they could more conveniently lay out the tiny components of the *opus vermiculatum* and the coloured grouts. Once dry, the panel on its mortar support was transported and set in the designated location in the rest of the pavement that was made *in situ*. Such panels are referred to as *emblemata* (1). This manufacturing process, that could be carried out close to the pavement to be decorated or much farther afield, spread throughout the Mediterranean; it led to the development of trade in these art objects over short and long distances alike. On Delos, the *œcus* with the Dionysus of the House of the Masks [214] provides an example of an *emblema* that is still in place: of the three panels of the main carpet, the two side ones, with centaurs, were made on the spot with the rest of the pavement whereas the large square central panel is an *emblema*, as can be seen from its slightly faulty positioning – it is not set straight and is too high in the overall composition of the carpet – forcing the mosaicists to offset the nearby border to camouflage a mistake they could no longer correct once this heavy panel had been laid down in the pavement mortar (see 6). Other fragmentary *emblemata* were found in the excavations, after the collapse of the upper storey where they had been laid out: this is the case of the panel of Lycurgus and Ambrosia [69], the doves on a bowl [168], or the Erotes with the lion [279] (see 25, 31, and 32).

Some of these Delian *emblemata* bear no trace of fixing mortar and can stand vertically without further support: such free-standing pictures (*pinakes*) that could be set in niches were part of the artworks displayed in the wealthiest homes (49 and 50). Conversely, when they were laid in pavements, these *emblemata* could also be removed, especially if the homeowner moved, as shown by a series of

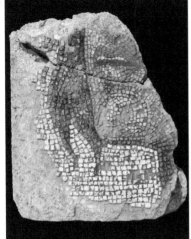

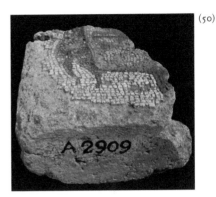

ground-floor pavements from which the panels have vanished [13, 72, 73, 75, 152, 165, 236, 325].

Evidence for a further technique of 'mixed' setting was found in Alexandria and certainly practised on other sites too: this involved making the finest parts of the design not *in situ* but prefabricating them on a table, on a thin plaque of mortar, and then inserting them into the design. This technique can be identified for the masks of the garland of the large *œcus* of the Insula of the Jewels, for the bust of Athena in the same pavement [68] (51), and for the bigae of dolphins [210] (see 14). This technique that consisted in prefabricating parts of the figured design in *opus vermiculatum* on a table meant they could certainly not be carried over long distances, unlike the *emblemata*, but they had to made up in premises close to the pavement for which they were intended.

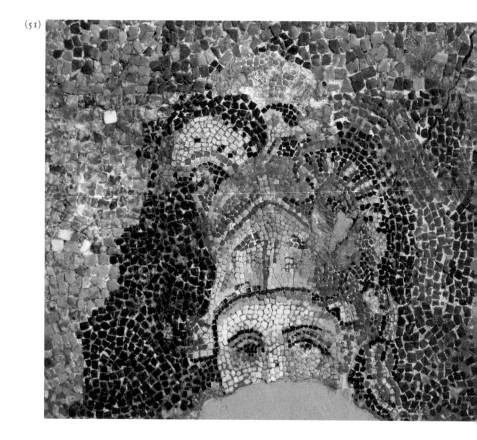

The Mosaics of Delos

Is there a Delian style of mosaic?

While it is certain that the mosaics of Delos share some common characteristics, is it right to speak of a Delian style as is sometimes done? Is this style peculiar to Delian mosaicists or was it that of its time? Comparable pavements are to be found on Samos, Rhodes, and Paros in particular. However, comparisons with contemporaneous mosaics are difficult because of the enormous proportion of Delian pavements in the group of those know for the same period. In the study of Hellenistic mosaics, Delos plays the same role as Pompeii in the study of paintings, for the same reasons of their exceptional state of preservation.

Yet analogies can be observed between the design of Delian pavements and that of the inside walls of houses. We have noted that, on floors, mosaicists alternated monochrome bands and coloured bands, 2D designs and 3D designs suggesting depth. This scansion of floors is found, in the same houses if not in the same rooms, on the vertical walls of structural (or architectural) style, painted and sometimes stuccoed: they display an alternating pattern of flat or moulded zones, either monochrome or with a geometrical, vegetal, and sometimes a figured design, rendered illusionistically to varying degrees. The work of Françoise Alabe has shown, for the House of the Seals and the House of the Sword (59D) in the northern quarter of the island, that the same decorative grammar governed the painted design of the ceilings. In addition, the inclusion in the structural style of the walls of the figured or vegetal frieze played the same role as that of the panels or figured bands in the pavements. There was therefore a certain unity of style in the decoration of rooms. This unity can be observed on Delos more than elsewhere for the same period since the houses have only been very partially conserved on the other sites. For some decades now, we have gained better knowledge of the structural style of painting of the eastern part of the Greek world and one can observe there the same characteristics, without it being possible to affirm that Delos played any particular part in the creation of this type of wall decoration that developed in Greece from the early fourth century BC. It is highly likely therefore that the same applied to mosaics, and the swift development of the town must have led to emulation among patrons who could

see their neighbours' newly built and decorated houses. The fact is that despite its rapid growth, the island was not a centre of artistic creation in the same way as the capitals of the kingdoms of the *koine**, foremost Alexandria, but also Pergamon, and certainly Antioch whose Hellenistic pavements are not known. The mosaicists working on Delos must have followed the developments in this luxury craft, making their own the technical processes and the iconographic schemes or decorative patterns from larger centres of artistic creations. Jean Marcadé mentioned Alexandria for the provenance of the *emblema* of the Dionysus of the House of the Masks [214]; it is sure that the pictorializing and illusionistic movement was developed there as from the late third century BC. But one might also see the Italic influence in the black grounded carpets like those of the House of the Seals [81], the Insula of the Bronzes [59], the House with a Single Column [179], or again the House said to be of Philostratus of Ascalon [196], where a statue honoured this leading banker of Delos who was born in Phoenicia and became a citizen of Naples.

In any event, it is certain that the Delian mosaicists also displayed originality. In this way, beside the pictorializing style giving precedence to the play of light on dark grounds [69] (52) and the illusionism of designs in *trompe l'œil* by polychromy, they produced flat figures on white grounds, graphically, as emblems of sorts like the ribboned trident and the dolphin around the anchor

(52)

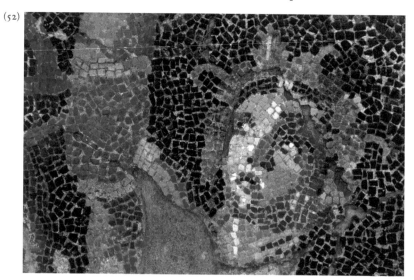

in the House of the Trident [228] (53 and 54). This mode of representation was to develop in the West during the imperial period.

Again as part of the illusionist movement, the Delian mosaicists rendered the projection of a sculpted coffered ceiling on the pavement of the *œcus* of the House of the Tritons [75] (55): this attempt to imitate architecture can be recognized from the thin band of dentils edging the main carpet, from the two square panels bounded by eggs and darts marking their 'recessing' relative to the plane of the ceiling/pavement, and from the treatment of the figures in black, grey, and white that renders by the shading the stone relief of the black grounded coffer. On the panel that has been conserved, a tritoness rows along holding a ribboned rudder, under the guidance of an Eros (56). Only the ribbon adds a dash of dark red colour. It is likely that the other panel, removed in Antiquity, portrayed a triton: these two panels depicted an amorous encounter of hybrid marine figures. More than an attempt to imitate archaic pebble mosaics as has been written, this pavement should be seen as a sophisticated demonstration of the illusionistic movement, prompting painters and mosaicists of the second and first centuries BC to reproduce on a necessarily plane surface architectural features that were naturally three-dimensional; and the projection on the floor of a roofing system (ceiling or vault) was to become a decorative scheme that was found in the mosaics of the imperial period.

Lastly, the very large pavement of the *impluvium* of the House of the Diadumenos [86] is composed of large cut pebbles alternating with bright polychrome stone chips (57). At the time the house was destroyed, the pavement was being laid or repaired: the stone chips and pebble pieces are not abraded and the excavations by the Ephorate of the Cyclades unearthed coloured stones prepared for use in the pavement; those very varied stones included fragments of obsidian, the naturally occurring black glass attested in the Cyclades. Probably coming from the collapse of the same architectural group, an upper storey pavement was made of chips of the same diversely coloured stones set in a white mortar. As in the main centres of the *koine*, the Delian mosaicists experimented with the techniques and materials in various combinations depending on the designs, the purposes of the rooms, and their location, upstairs or downstairs.

The mosaics of Delos tell us little of the origins of the patrons who commissioned them, although they came from very varied lands during these times of 'economic boom' when traders and financiers from all around the Mediterranean rubbed shoulders on the island: a few clues can only barely be recognized in the House

Is there a Delian style of mosaic?

(53)

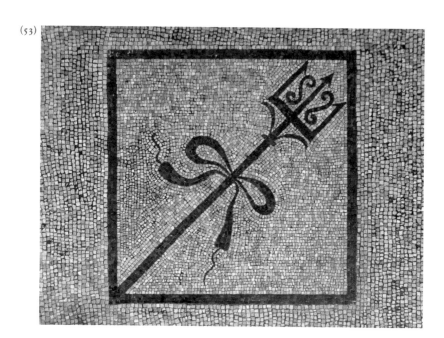

(54)

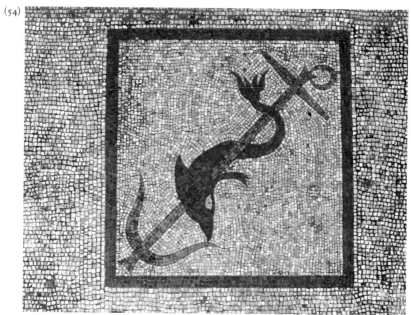

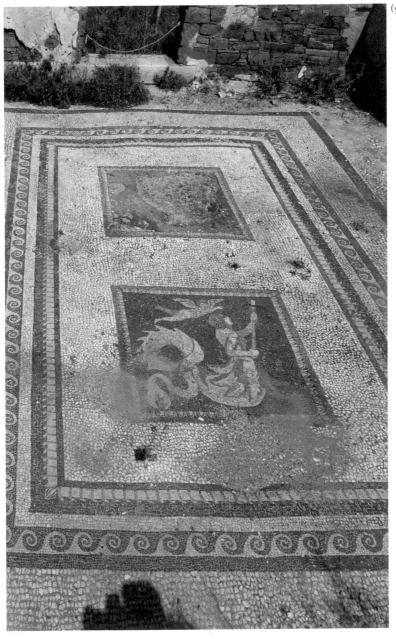

Is there a Delian style of mosaic?

(56)

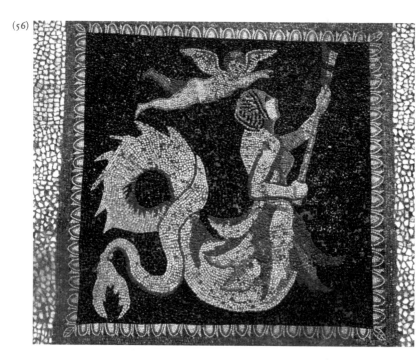

(57)

of the Dolphins. Rather than marking their own cultural identities, these wealthy patrons adopted one and the same life style on Delos, that of the Greek elites, as attested by the architecture and decoration of their houses. However, some of them had already led such a life style in their homelands and this type of domestic decoration, inspired by Hellenistic palaces, would not have been unfamiliar to them, as proven by the refined mosaics and the structural style paintings discovered in recent decades around the shores of the eastern Mediterranean and throughout the *koine*. The decoration of the houses of Delos is a manifestation of this aulic art that the elites adopted, adapting it to their needs and to their means, in both East and West, especially in Sicily and in Magna Graecia, in Rome, and then throughout Italy.

On Delos, the patrons who commissioned mosaics followed, as they did for wall paintings, the standards of decoration of the wealthy residences of the day. Mosaics undeniably had a practical character and contributed to home comforts, but they also provided the opportunity to bring artworks into the domestic sphere. In the absence of painted pictures on wooden panels (*pinakes*), easel painting for which we have no evidence in the houses, the large figured panels of mosaics were, together with statues, the only large images to be seen in the domestic setting: indeed the rare painted figures on walls were only to be seen on friezes about 20 cm high. Apart from the tribute they paid to the god, the *emblemata* of more than a metre in size in the House of the Masks and the House of Dionysos must have greatly impressed visitors with their beauty but also the exotic character of the god's highly ornate oriental dress and of his mounts, big cats that very few would actually have seen (58). Possessing and showing off such impressive artworks could not but increase the status of their owners. Accordingly, in their homes that also had economic and representative functions, the owners displayed their wealth, their good taste, and their adherence to the Greek culture of the *koine* by making some pavements very luxurious items, that were remarkable in their iconography, their colours, and their sparkle. Apart from the pleasure of living in an agreeable setting, the patrons sought the social recognition that went along with the standing they displayed. In the residential quarters, among neighbours, business associates or competitors, there must have been considerable emulation or even some degree of rivalry as to the comfort and luxury displayed in their grand abodes.

Is there a Delian style of mosaic?

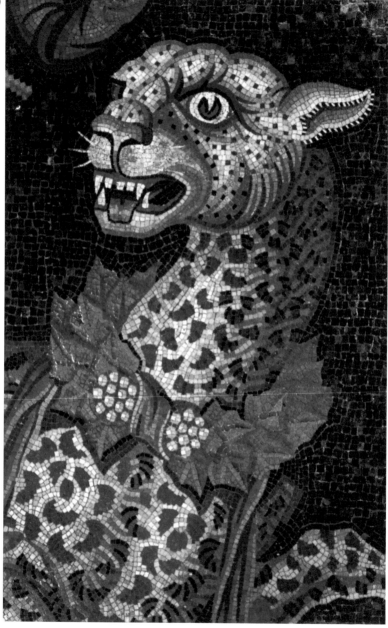

The Mosaics of Delos

Glossary

Aulos: sort of oboe with a double reed mouthpiece.

Auriga: chariot driver.

Bead and reel: motif in which round or horizontal oval beads alternate with vertical oval beads or lozenges.

Biga: team of two animals hitched together (horses, dolphins, etc.).

Caduceus: staff around which serpents wind themselves, an attribute of Hermes and of Asclepios, the god of healing.

Chlamys: sort of cape, fastened around the neck, that served as a men's overcoat.

Corymb: fruit of ivy, one of Dionysus' plants.

Dentils: protruding quadrangular elements beneath an Ionic cornice; this sculpted architectural motif was reproduced illusionistically in mosaics and paintings.

Eggs and darts: motif in the form of a half-egg with the tip pointing downwards, alternating with darts; this sculpted architectural motif was reproduced illusionistically in mosaics and paintings.

Impluvium: open-air area in the centre of the courtyard, for collecting and storing rainwater in a cistern below. The floor of the *impluvium* has a waterproof coating of mosaic or paving stones.

Kantharos: metal or terracotta drinking vessel with upward-extended handles.

Koine: common cultural area of the Greeks, much extended after Alexander's conquests.

Krater: terracotta or metal recipient for mixing wine and water and from which drinks served to guests were drawn.

Metopes: rectangular plaque, with or without decoration, between the triglyphs of a Doric frieze.

Œcus: ceremonial hall, salon, reception room of a house, used especially for banquets. Some houses had several *œci*, with the *œcus maior* being supplemented by a smaller *œcus minor*.

Orpiment: arsenic sulphide, a bright yellow pigment of mineral origin used notably in paintings.

Panathenaic amphora: amphora, often associated with a palm frond, awarded to winners of games (especially the Panathenaic Games at Athens).

Peristyle: set of porticoes arranged on four or sometimes three sides of the courtyard; **Rhodian peristyles** have one side higher than the others, letting more light into the large ceremonial rooms behind them.

Petasos: broad-brimmed hat of travellers, characteristic of Hermes.

Satyrs: nature demons, depicted as humans with animal features.

Sileni: generic name for aged satyrs*; it is also the name of a particular one of them who raised Dionysus.

Symposion: second part of the banquet, when drinking went on.

Thiasus: suite, group of followers of Dionysus: the maenads, satyrs, and sileni.

Thyrsus: staff tipped with a pinecone or a sprig of leaves, with a knotted and sometimes ornate ribbon. Attribute of Dionysus and the members of his thiasus.

Torus: convex horizontal moulding, used in architecture and transposed illusionistically in mosaics and painting.

Tympanon: tambourine, a musical instrument that Dionysus and the members of his thiasus beat and hold aloft.

Further reading

P. ASIMAKOPOULOU-ATZAKA, *Ψηφιδωτά δάπεδα: προσέγγιση στην τέχνη του αρχαίου ψηφιδωτού: έξι και ένα κείμενα* (2019).

P. BRUNEAU, *EAD* XXIX. *Les mosaïques* (1972).

P. BRUNEAU, *Études d'archéologie délienne*, BCH Suppl. 47 (2006).

P. BRUNEAU, J. DUCAT, *Guide de Délos*, 4ᵉ éd., Sitmon 1 (2005).

M. BULARD, *Peintures murales et mosaïques de Délos*, Mon. Piot 14 (1908).

J. CHAMONARD, *EAD* VIII. *Le quartier du théâtre* (1922-1924).

J. CHAMONARD, *EAD* XIV. *Les mosaïques de la Maison des masques* (1933).

K. M. D. DUNBABIN, *Mosaics of the Greek and Roman World* (1999).

R. GINOUVÈS, R. MARTIN, *Dictionnaire méthodique de l'architecture grecque et romaine*, I : *Matériaux, techniques de construction, techniques du décor*, dictionnaire multilingue (1985).

A.-M. GUIMIER-SORBETS, « Dionysos dans la maison grecque : iconographie des mosaïques des IIᵉ et Iᵉʳ siècles avant J.-C. », in *O Mosaico romano nos centros e nas periferias: originalidades, influências e identidades* (2011), p. 175-188.

A.-M. GUIMIER-SORBETS, *Mosaïques d'Alexandrie, pavements d'Égypte grecque et romaine*, Antiquités alexandrines 3 (2019) ; *Mosaics of Alexandria: Pavements of Greek and Roman Egypt* (2021).

A.-M. GUIMIER-SORBETS, M.-D. NENNA, « L'emploi du verre, de la faïence et de la peinture dans les mosaïques de Délos », *BCH* 116.2, 1992, p. 607-631.

A.-M. GUIMIER-SORBETS, M.-D. NENNA, « Réflexions sur les couleurs dans les mosaïques hellénistiques : Délos et Alexandrie », *BCH* 119.2, 1995, p. 529-547.

J.-C. MORETTI (éd.), *EAD* XLIII. *Atlas* (2015), on line : http://sig-delos.efa.gr.

J.-C. MORETTI, *1873-1913, Δήλος: εικόνες μίας αρχαίας πόλης που έφερε στο φως η ανασκαφή / Délos : images d'une ville antique révélée par la fouille / Delos: Images of an Ancient City revealed through Excavation*, Patphoto 3 (2017).

Figure captions

Cover picture – House of Dionysos [293], detail of the tiger (photo A. Guimier, ArScAn).

Map 1 – Location of monuments on Delos where mosaics were found (after J.-C. Moretti, *Atlas* [ed.], 2015).

Map 2 – Floor plan of the House of the Masks (after *EAD* XIV, pl. I).

1. Courtyard of the House of the Dolphins in 1911 (photo EFA).
2. House III S of the Theatre Quarter [270] (photo A.-M. Guimier-Sorbets, ArScAn).
3. House of the Trident, restored perspective view of the courtyard (water colour A. Gabriel, 1911; Albert Gabriel collection, CCJ).
4. House of the Trident, floor plan (A. Gabriel, 1909; Albert Gabriel collection, CCJ).
5. House of the Trident [234], amphora, wreath, and palm frond (photo P. Collet, EFA).
6. House of the Masks [214] complete mosaic carpet (photo P. Collet, EFA).
7. House of the Masks [214], *emblema* with the Dionysus (water colour V. Devambez, EFA).
8. House of the Masks [215], mask of bearded man (photo P. Collet, EFA).
9. House of the Masks [216], music scene (water colour V. Devambez, EFA).
10. House of the Dolphins [209], Tanit sign (photo P. Collet, EFA).
11. House of the Dolphins [210], courtyard pavement (photo P. Collet, EFA).
12. House of the Dolphins [210], dolphins of Dionysus (EFA).
13. House III N of the Theatre Quarter [261], outer bands of marble chips (photo A.-M. Guimier-Sorbets, ArScAn).
14. House of the Dolphins [210], Eros on one of Poseidon's dolphins (photo A.-M. Guimier-Sorbets, ArScAn).
15. Fourni House [326], floor in *opus signinum* (photo A.-M. Guimier-Sorbets, ArScAn).
16. House II B of the Theatre Quarter [242], cubes (photo A.-M. Guimier-Sorbets, ArScAn).
17. House west of the Clubhouse of the Poseidoniasts [45, 44], chequerboard pattern of tesserae (photo A.-M. Guimier-Sorbets, ArScAn).
18. House with a Single Column [171], courtyard pavement (photo A.-M. Guimier-Sorbets, ArScAn).
19. House of the Dolphins [210], meander and waves (photo A. Guimier, ArScAn).
20. Fourni House [325], *trompe-l'œil* torus and waves (photo A. Guimier, ArScAn).
21. House of the Lake, upper storey [95], rosette (photo A. Guimier, ArScAn).
22. Insula of the Jewels [68], complete main carpet (photo A. Guimier, ArScAn).
23. Insula of the Jewels [68], detail of the garland (photo A Guimier, ArScAn).
24. House III N of the Theatre Quarter [261], dolphin twisting around anchor (photo P. Collet, EFA).
25. House B of the Inopos Quarter [168], *emblema* with doves (photo A. Guimier, ArScAn).
26. House of Dionysos [293], *emblema* with Dionysus (photo A. Guimier, ArScAn).
27. House of Dionysos [293], head of Dionysus (photo A. Guimier, ArScAn).
28. House of Dionysos [293], kantharos (photo A. Guimier, ArScAn).
29. House B of the Inopos Quarter [169], *emblema* with leopard (photo A. Guimier, ArScAn).
30. House of the Dolphins [210], detail of waves with griffins and two-stranded guilloche (photo A. Guimier, ArScAn).

31. Insula of the Jewels, upper storey [69], Lycurgus and Ambrosia (photo P. Collet, EFA).
32. House IV B of the Theatre Quarter, upper storey [279], the three fragments (photo A. Guimier, ArScAn).
33. House IV B of the Theatre Quarter, upper storey [279], the three fragments, montage on *emblema* from Campania housed in the British Museum (photo A. Guimier, ArScAn).
34. Insula of the Jewels [68], central panel (photo P. Collet, EFA).
35. Insula of the Jewels [68], detail of the central panel and outline of the column, livestock shed, and animals (photo A. Guimier, ArScAn).
36. House of the Dolphins [210], signature [Askle]piades of Arados (photo A. Guimier, ArScAn).
37. Agora of the Italians [25], hydria and palm frond with inscription (water colour M. Bulard, EFA).
38. Waves with lead strips, Delos Museum (photo A.-M. Guimier-Sorbets, ArScAn).
39. House of the Seals, wave template, Delos Museum (photo A. Guimier, ArScAn).
40. Fourni House, upper storey [334], fragments with traces of paint (photo A. Guimier, ArScAn).
41. Insula of the Jewels, upper storey [69], garment of Ambrosia (photo A. Guimier, ArScAn).
42. Insula of the Jewels [68], detail of the garland: photo of the current state and attempt at colour restoration depending on the deterioration of materials (photo A. Guimier, ArScAn).
43. House of the Masks, *emblema* with Dionysus [214] restoration of colours of complete mosaic and detail of garment (water colours N. Sigalas, EFA).
44. House of the Tritons, upper storey [79], rosette with bird, detail under normal light and infrared light (photo A. Guimier, ArScAn).
45. Fourni House, upper storey [334], fragment with glass tesserae with blue-coloured mortar: detail under normal light and infrared light (photo A. Guimier, ArScAn).
46. House of the Tritons [78], band of terracotta tesserae on red mortar (photo A. Guimier, ArScAn).
47. House of the Comedians, fragment from upper storey with chips in red-coloured mortar (photo A. Guimier, ArScAn).
48. House of the Comedians, *triclinium* [72] (EFA).
49. Kynthion [202], *emblema* fragment viewed face on (photo A. Guimier, ArScAn).
50. Kynthion [202], *emblema* fragment viewed edge on (photo A. Guimier, ArScAn).
51. Insula of the Jewels [68], detail of the helmeted head of Athena (photo A. Guimier, ArScAn).
52. Insula of the Jewels [69], detail of the *emblema*: head of Ambrosia (photo P. Collet, EFA).
53. House of the Trident [228], trident panel (photo A. Guimier, ArScAn).
54. House of the Trident [228], dolphin around anchor panel (photo A. Guimier, ArScAn).
55. House of the Tritons [75], complete pavement with the tritoness (photo A.-M. Guimier-Sorbets, ArScAn).
56. House of the Tritons [75], detail of the tritoness panel (photo P. Collet, EFA).
57. House of the Diadumenos [86], stone chip courtyard floor (photo A.-M. Guimier-Sorbets, ArScAn).
58. House of the Masks [214], detail of the leopard head (photo P. Collet, EFA).

Les mosaïques de Délos

Contents

Published with the support
of the J.M. Kaplan Fund

Printed in September 2022
by Sepec numérique (France)

ISBN: 978-2-86958-584-3

Legal deposit: 4th quarter 2022

Translation and editing of texts in english: Christopher Sutcliffe

Director: Véronique Chankowski – Publishing manager: Bertrand Grandsagne – Editorial follow up: EFA – Graphic design,
prepress: EFA, Guillaume Fuchs